JN325178

えぞももんがのきもち

西尾博之

北海道新聞社

ぼくはエゾモモンガ

サイズは握りこぶしくらい！

エゾモモンガは、エゾリスやシマリスと
違い夜行性の動物です。
人間の目では、なかなか見つけにくいも
のですが、静かな夜の森には、けっこう
たくさんのモモンガがいます。
モモンガの大きさは、握りこぶしくらい。

体長　15 〜 18cm
体重　80 〜 120g
尾長　10 〜 14cm

> 皮膜を広げても
> 手のひらサイズ！

リスのなかでは唯一、飛びます。
手足を広げると手のひらくらいの大きさで、手と足の間に皮膜があります。
手足をいっぱいに広げ、空気の抵抗を利用して木から木へと音もなく滑空します。

巣に
もどろうかな？

よいっしょ！

モモンガの巣穴は、木の高い所に
あることが多く、ほとんどがアカ
ゲラやオオアカゲラの古巣を利用
しています。

日没後、およそ 30 分以内に顔を出し、活動が始まります。
日の出前には、ほぼ決まった時間に決まった方向から飛んで帰ってきます。
一晩に数回、外出するようです。

うんち!

起きてまずすることは…

モモンガのうんち

モモンガは、巣から出てくると一番最初に排泄をします。ふんは米粒より少し大きく、形も似ています。ほぼ決まった場所に排泄するので、冬にモモンガの巣穴を探すにはよい目印になります。
冬眠はしません。

これは
おしっこ！

うんち出そう…

滑空は、通常20〜30mの飛行距離ですが、
時折70〜80m以上飛ぶこともあります。
高い所から低い所に飛び移るという感じで飛んできます。
尾で舵をとり急旋回もします。

ハルニレの冬芽を食べるときは、枝を噛み切り、手で持って食べて、食べ終わるとその枝を落とします。冬に雪の上にこの枝がいっぱい落ちている所があれば、そこがモモンガの食痕です。探すための目印になります。

> 針葉樹の葉！

> ハルニレの冬芽

通常は樹上に積もった雪や葉についた水滴を飲んで、水分補給をしますが、ある日、川の水を飲むモモンガに出会いました。これは非常に珍しい光景です。

たまに下に降りて
雪も食べるんだ

ひとりぼっちは
寂しいと思ったら…

仲間が上に
いたよ♪

モモンガは、敵をつくらず争わない攻撃性のない動物。
夏は単独で行動しますが、冬になると一ヵ所の巣穴に集まり、身を寄せ合って温め合いながら、厳しい冬を乗り越えます。

まだいた!

みんなといっしょだと
あったかーい!

モモンガの恋の季節は、
およそ2〜3月ごろと秋の
9〜10月ごろ。

みんなで
お月見♪

春だから昼も
起きてるんだよ

繁殖期になると、まれに日中巣穴から出てくることがあります。
また、採食ができないほどの嵐の翌朝に出てくることもあります。

いいコ、
いないかなぁ

ここにいるよ♥

モモンガは、どんな季節でも日が暮れると、
巣穴から顔を出して
⇨ おしっことうんち
⇨ 上手に飛んで
⇨ エサを探して
⇨ 食べて
⇨ 巣穴に戻る
をくりかえしています。
1回の外出はだいたい1時間半くらい。

さぁ、今夜もいつもと同じ
一日が始まります！

エゾモモンガのこと

ネズミ目（げっ歯目）リス科
英名 Russian flying squirrel　学名 *Pteromys volans orii*

　北海道に生息するエゾモモンガは、タイリクモモンガの亜種で、本州に生息するニホンモモンガとは別種です。体毛の色は頰から胸、おなかにかけて白く、背中は冬は灰色、夏は茶色に毛変わりします。体のわりに大きな黒い目をして、体長はメスよりオスの方が大きめです。手と足の間に皮膜があるのが特徴で、リスの仲間では唯一、飛びます。その皮膜を使い、木から木へと滑空します。夜行性で、活動中に排泄や食事をします。樹木の芽や花、葉、種子などを食べます。
　巣はキツツキ類の古巣を使いますが、クマゲラの巣は大きすぎて天敵に狙われやすいため、アカゲラやオオアカゲラなどの巣を使います。巣材は小枝や樹皮、コケ類などです。
　繁殖期は春先と秋の年1〜2回で、1回に2〜5匹生みます。通常は鳴かないのですが、繁殖期のみ「ズィーズィー」と小さな声で鳴きます。
　天敵にはエゾクロテンやエゾフクロウ、アオダイショウなどがいます。

あとがき

　モモンガを撮影するには、まず生態や習性を観察し、行動パターンを把握しなければなりません。それには毎日森に通う必要があります。

　特にモモンガは夜行性の動物なので、夜な夜な薄暗くなってから、または日の出前にカメラを背負って森の中に入ります。薄暗い森に一人でいるのは怖いです。だんだん暗くなり静寂の中でモモンガが出てくるのを待っているときには、枯葉のガサガサという音にさえ驚いてしまいます。

　撮影時期は、モモンガの食痕やふんなどを見つけやすい冬が多くなります。冬になれば熊の心配はなくなりますが、寒さが辛く、全身にカイロを貼り付け重ね着をして防寒対策をします。しかし、目のまわりだけは防寒できないので、－20℃ともなると、その部分が寒いというよりむしろ痛くなります。

　そんな辛い思いをしながら心細い気持ちで待っていると、巣穴から"ポコッ"とモモンガが顔を出してくれる瞬間は、幸せな気持ちでいっぱいになります。どんなに寒い日でも、どんなに悪天候の日でも、その幸せな気持ちがあったから毎日通い続け撮影をすることができました。

　この写真集を通してモモンガのかわいらしさを伝えることができれば幸いです。

西尾 博之（にしお ひろゆき）

1963年生まれ、苫小牧市在住。1994年から自然や野生動物を中心に撮影を始める。野生動物の生命の輝きやたくましさ、かわいい仕草に魅せられ撮影に取り組んでいる。フィールドは北海道・樽前山麓の自然。
2007年、第11回ナショナルジオグラフィック写真コンテスト優秀賞受賞。
https://facebook.com/hirosiro

ブックデザイン・DTP　蒲原裕美子（時空工房）

えぞももんがのきもち

2016年4月20日　　初版第1刷発行
2022年6月1日　　初版第3刷発行

著　者	西尾博之
発行者	菅原　淳
発行所	北海道新聞社
	〒060-8711　札幌市中央区大通西3丁目6
	出版センター　（編集）TEL　011-210-5742
	（営業）TEL　011-210-5744

印刷・製本　　株式会社アイワード

落丁・乱丁本は出版センター（営業）にご連絡下さい。お取り換えいたします。
© NISHIO hiroyuki 2016 Printed in Japan
ISBN978-4-89453-824-5